-÷ First Lesson ÷-
write your name

- -

-÷ NOW ÷-
DRAW your Name!

- -

Dedicated to my Mom
and her lovely handwriting
&
Fred who helps
maintain my sanity

ISBN: 978-1-4521-2558-9

Manufactured in China

Illustration by Mary Kate McDevitt
Design by Ryan Hayes
Author photo by Fred DiMeglio

20 19 18 17 16 15 14 13

Chronicle Books LLC
680 Second Street
San Francisco, California 94107
www.chroniclebooks.com

Hand-Lettering Ledger

Mary Kate McDevitt

CHRONICLE BOOKS

San Francisco

CONTENTS

INTRODUCTION

Hand lettering takes the simplest form of communication and transforms it into an expressive art form. Exploring the nuances of twenty-six little letters consistently inspires wonder and excitement.

At a young age, I was interested in art, and I found myself doodling in the margins of every notebook in my locker. In fact, you might say I took it to an obsessive level. Every square inch was a blank canvas and taking notes only got in the way. Letterforms always seemed to be a recurring theme and provided endless subject matter.

Later, at Tyler School of Art, we students were encouraged to try a variety of courses before deciding on our major. The courses ranged from painting, to fabric dyeing, to sculpture and illustration, but I really fell in love with design. In the graphic design program, most of my classmates focused on slick design styles, but I found inspiration from the textures I created in my painting class, and the hand-drawn look created by my pen.

When I incorporated handmade textures and illustrations into my projects, I started to find my style. I also began playing more

with hand lettering, which is where I really found my voice as a designer. At the time I didn't realize lettering was a career path, but it was fun to work with, and I think the use of hand lettering made all my projects feel more cohesive and personal.

After graduating, I worked as a designer at a studio in Lancaster, Pennsylvania. I found myself glued to the computer, trying to deliver that slick design style that didn't come so naturally to me. I designed by day but came alive at night when working on hand-painted lettering and printing posters. I spent all my free time in my home studio working on silk-screen prints and Mini Goals Chalkboards for my Etsy shop. As my shop gained more interest from customers, my work caught the eye of some of my favorite design blogs. From the new traffic to my shop came new inquiries, not only for orders but also for custom lettering for small businesses. Not to mention a fairly popular

TODAY I WILL practice HAND LETTERING HOORAY!

publishing company (ahem, Chronicle Books), which published my first notepad, the *Mini Goals Notepad*. Three years later, I gathered the courage to freelance full-time and moved cross-country to Portland, Oregon. Over time, I started to do custom lettering for a variety of clients, including *Fast Company*, Nintendo, *Every Day with Rachael Ray* magazine, the United States Post Office, and *O, The Oprah Magazine*. Today, I continue lettering, full-time, in Brooklyn, New York.

Every time I start a project, I'm so excited about its promise. I research the project, sketch, and explore new lettering possibilities. And my sketchbooks are absolutely essential to my process. I always have one with me, and I hope you'll always have one—maybe even this one—with you as you embark on your own adventures in lettering.

The Hand-Lettering Ledger introduces you to eleven primary styles, from simple sans serifs to black letter to elaborately illustrated letters, and teaches you how to apply them to your projects. The lessons at the beginning of the sketchbook equip you with the skills needed to draw in these styles. Then the back of the sketchbook is filled with practice sheets—some guided, some totally open-ended—where you can get to work and watch your skills improve.

I hope my experiences as a letterer will help guide you on your quest to learning hand lettering. Remember: The tips and information in this book are not rigid. They are here to inspire you and act as a primer for your own adventures in lettering. Personal interpretation is recommended and strongly encouraged. Have fun!

What is Lettering?

Lettering is the art of drawing letters. It is not to be confused with "typography" or "calligraphy." These terms get loosely thrown around, and even I was confused about the terminology until not so long ago. While most people will know what you are talking about if you point to a hand-lettered piece and say, "I love that typography," it just isn't technically correct. This book is meant to instruct, so let's get this sorted.

Typography is the art of arranging type; specifically, to be prepared for press. Arranging type involves picking the typeface and the point size and adjusting the leading, tracking, and kerning. One key factor that differentiates typography from lettering is that in lettering you do not use a typeface. Because, of course, lettering is completely customized and hand drawn.

Calligraphy is a bit more similar to lettering, but calligraphy is the design and execution of lettering, written with one smooth stroke using a brush or pen. The key distinction is that in lettering, letters are *drawn* and in calligraphy they are *written*. And calligraphy requires little or no retouching.

Typeset
↓
Typography
=VS=
Calligraphy
↑
written
=VS=
LETTERING
↑
DRAWN

So why bother learning how to hand letter?

Lettering allows you to completely customize the letter, word, or phrase. This is helpful for projects in which the type has to be illustrative or you just can't find the right existing typeface. It allows you to fit the lettering to the context so your concept is fully realized. It also gives the project a distinct and cohesive look. You can push the boundaries of what makes a letter legible and how many ways you can draw the same letter. Lettering can be imaginative, conceptual, fancy, or fun. It's an art form that most folks can recognize and appreciate. It's also helpful (obviously) when your project needs to have that hand-drawn or hand-painted look. Why fake it when you can make it?

Like most skills and crafts, lettering requires practice. Lettering can certainly seem daunting at first. You've written letters over and over for years, but now drawing them freehand may seem impossible. At first, your letters will be wonky and all over the place, but as with anything, practice makes perfect. Soon you will start to recognize mistakes and finally achieve the perfect curve. And you'll use the lessons and tips in this book to venture out in new ways to draw that letter.

One of the great parts of lettering is that you don't have to adhere to all the rules that go along with typography. There is no real leading or kerning to apply. You may come up with your own rules and techniques along the way, but it's great to start loose. I enjoy the spontaneity of lettering. A little squiggle could spark inspiration for a word, and that quick sketch might just be the final piece.

When you are lettering, it's important to understand the mood and context of the piece to know what lettering style to apply. You are informing the reader, as well as creating a beautiful composition; the direction you take should communicate both.

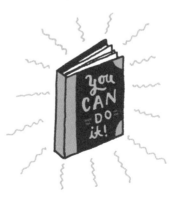

-»LETTERING *tools*«-

··•··

The tools required for lettering are simple and inexpensive. You can find most of them at your local art store. Most of the lettering you create in the beginning will be with simpler tools, but over time, feel free to experiment with new brushes, nibs, and paints.

MECHANICAL PENCIL

Brush Pen

FINE-TIP *Marker*

PENCIL

CHISEL-TIP MARKER

Bonus POINTS *if you use a* FEATHER PEN!

Drawing =INK=

WATERPROOF -INK-

PENCIL SHARPENER

compass

Brushes

FLAT

POINTED

Pen NIB holder

PEN NIBS

SCRAP PAPER

Tracing PAPER

Eraser

1 2 3 4 5 RULER

Lettering terminology

ASCENDER
t HEIGHT
BODY LINE
x-HEIGHT
DESCENDER

SCRIPT

DOWNSTROKE
(MORE PRESSURE)

CROSS STROKE

LEAD-IN-STROKE

LOOP

EXIT STROKE

UPSTROKE
(LESS PRESSURE)

The
QUICK
BROWN
FOX JUMPED
→ OVER ←
the LAZY
· DOG ·

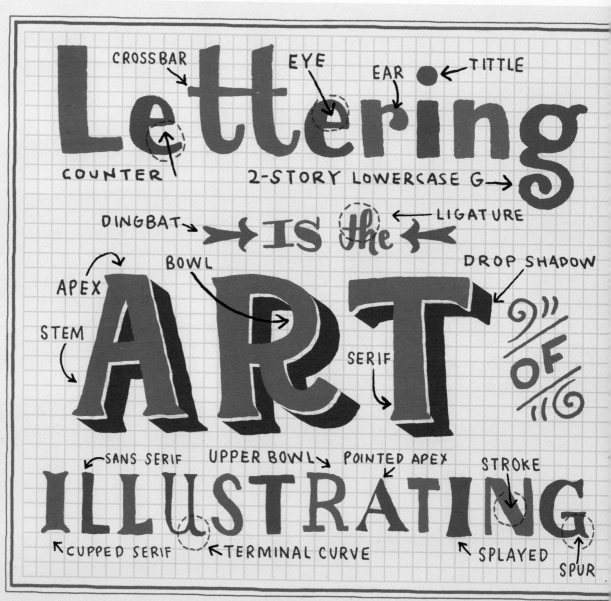

CROSSBAR

EYE

EAR

TITTLE

COUNTER

2-STORY LOWERCASE G →

DINGBAT

IS the

LIGATURE

APEX

BOWL

DROP SHADOW

STEM

SERIF

SANS SERIF

UPPER BOWL

POINTED APEX

STROKE

CUPPED SERIF

TERMINAL CURVE

SPLAYED

SPUR

I catch myself describing the terminology for letters incorrectly all the time. But rather than calling everything "the thingy that hangs off the G," you might avoid confusion (and make yourself sound smart) if you call it a descender. Here are a few of the more common terms when describing letters.

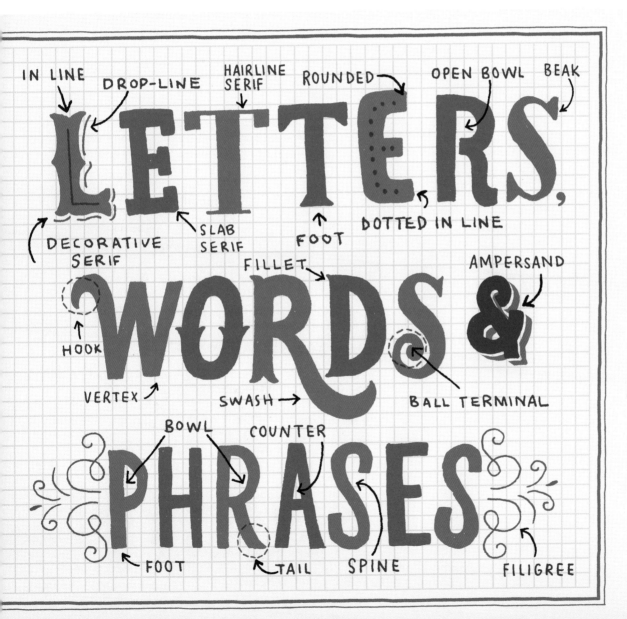

REGULAR

CONDENSED

EXTENDED

LIGHT FACE

BOLD FACE

REGULAR

The DO'S & DON'TS of LETTERING

You may notice that the word or phrase you've drawn looks off, but it can be hard to pinpoint the exact problem. Here are tips on common issues to look for when you review your work.

SQUOOSH

When you want to change the width or height of a word, it can be tempting to stretch your original drawing. This can make your work look strange and will be spotted a mile away. Instead, use your stretched image as a guide and redraw the letter forms. That way you can be sure that the proportions remain true.

ON A DIET — ORIGINAL
ON A DIET — INCORRECT
ON A DIET — CORRECT

WIDE — ORIGINAL
WIDE — INCORRECT
WIDE — CORRECT

AWKWARD!

Reworking your initial drawing can be crucial to producing a high-quality piece. If it's one letter you keep tripping over, practice drawing it over and over, pick the best one, and use that one for your final.

In these examples, the letters have strange proportions; the apexes of the Ws are too low, the swashes are not smooth, and the drawing is too rough.

AWKWARD — INCORRECT
AWKWARD — CORRECT

Awkward — INCORRECT
Awkward — CORRECT

ANCHORS AWAY

If you don't work with a tablet, but you need the lettering to be digital, your best option is probably to live trace, which I touch on again later. Steer clear of default when adjusting the settings to live trace. Once you get the setting you like, you probably need to fix those anchor points.

Here, the default live trace version has lost the essence of being hand-drawn. If you are going for a smoother look, trace with the pen tool, so you have total control.

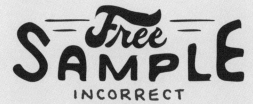
Free SAMPLE — INCORRECT

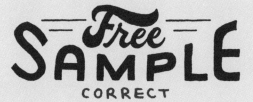
Free SAMPLE — CORRECT

There is a point where swirls go from looking like a beautiful gust of wind filled with dandelions to a knotted mess of rats' tails. Sometimes, less is more. Working with symmetry can be helpful for creating an even flow of curves.

These twenty-six letters allow worlds of exploration, and playing with proportions is particularly fun. Just keep in mind that proportions play a big part in readability. For example: *M* and *W* are wider than they are tall, and *B*, *E*, *F*, *J*, and *L* are half as wide as they are high.

In order to make your letters appear to be evenly sized, you often have to eyeball it. The letter *O* should extend above and below the baseline to appear the same size as the other letters. This rule applies to letters with a curve, such as *C*, *J*, *G*, *O*, *Q*, *S* and *U* and pointed letters such as *A*, *M*, *N*, *V*, and *W*.

INCORRECT

CORRECT

RABBITS

INCORRECT

RABBITS

CORRECT

E — HALF of ITS HEIGHT V — 3/4 of *its* HEIGHT O — EQUAL TO *its* HEIGHT M — WIDER THAN *its* HEIGHT

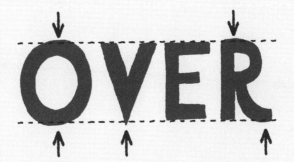

OVER

LETTERS THAT ARE ROUNDED or POINTED MUST EXTEND ABOVE and BELOW BASELINE

N N

INCORRECT CORRECT

THE DIAGONAL STROKE of AN N SHOULD BE THICK

W W

INCORRECT CORRECT

THE THICK STROKE of A W SHOULD ALTERNATE

E E

INCORRECT CORRECT

CROSSBAR of an E SHOULD BE SLIGHTY SHORTER

W M

ALTERNATE STROKES of A W ARE PARALLEL
NO TWO STROKES OF AN M are PARALLEL

A W IS <u>NOT</u> an UPSIDE DOWN M

÷ Find your inspiration ÷

Using reference material is an essential resource as you develop your own personal style. Historic reference is an especially rich source of inspiration for lettering. I've found inspiration in everything from packaging for laxatives to a sign that was hand painted in the 1920s. And I think part of what makes lettering so popular is the desire to carry on that tradition of carefully creating hand-lettered designs. I'm getting teary-eyed just thinking about the history of lettering.

While finding inspiration is important for all artists, it's important to recognize when it becomes copying. You can pore over vintage type that can easily be found in online antique directories, sites like Shorpy.com and Letterology.com, or you can visit your local historic district where you may find hand-lettered works that are still hand painted on the side of buildings. Take that inspiration and practice in your *Hand-Lettering Ledger*. Then when you are ready to take on a final project, work from your own sketches or from memory. You will end up with a more individual piece, with your own distinctive style, when it comes from an honest place.

DIGITIZING *your* LETTERING

When it's time to colorize your lettering and finalize the image, it's important to have a clean drawing. Some folks use colored pencils to sketch out their piece, and then, once it's scanned in, bring it into Photoshop, where one can hide the cyan channel leaving the black-inked drawing. Blue or red colored pencils are a great choice for sketching because they'll disappear when scanned.

When scanning your drawing, scan it at 600 dpi; I think that gives you the cleanest results. Now that the drawing is ready to be digitized, bring it into your vector program. I use Adobe Illustrator to vectorize my lettering, but there are other programs, like Vector Magic, that also work. Find out which works best for you. Now you should have a beautiful vector tracing that looks just like your drawing. If it happens to lose its magic, you may need to redraw your lettering so it keeps its hand-drawn beauty and doesn't look like a scratchy mess. It happens. While perfection is not necessarily our end goal, that scrumptious hand-drawn edge certainly is.

Once you have created a beautiful hand-lettered piece, you may want to finish it by adding color in the computer.

1. Scan your drawing in at 600 dpi or higher.

2. Open the scanned files in Photoshop to add contrast and get rid of any colored sketch lines. You can do this by hiding the cyan channel. Clean up other specks that may have snuck in from the scanner.

3. Open your file in Illustrator (or Vector Magic) to digitize your lettering, while keeping the hand-drawn edge.

4. Go to live tracing. Then choose Options and play with the threshold, path fittings, and minimize settings to get the effect you need. I find that it is important to maintain the rough, hand-drawn edges of my letters, so I use a higher threshold and a low path fitting. Preview your options before you begin, as it can take a while to trace.

5. Click Enhance.

6. You have a vector image of your hand lettering, and now it's ready for color.

19

SERIF

A serif is a small line, flourish, or embellishment trailing from the main stroke of a letter. Aside from the decorative element, serifs were added to augment the legibility of letters.

221 B BAKER ST. LONDON

I SAID, PIANI NOT PIANO

PROPER MODULATION

SKILLS THAT WILL IN TURN PAY THE BILLS

SURF'S UP!

BLUE JEANS

TOOLS ✒ A fine-tip pen or marker

 1 Lightly sketch out your phrase in pencil, considering the sizing and how the word is going to fill the composition. Try lettering your phrase at an angle or in an arc for a more dynamic look.

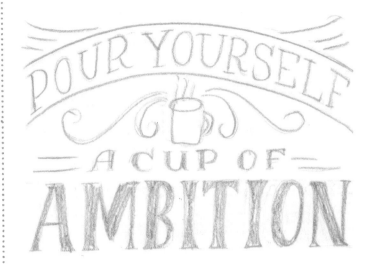

 2 With a pencil, lightly go over the word again, this time considering the styling of the word. What kind of serif will you use? Close up or widen any spaces that look off to you.

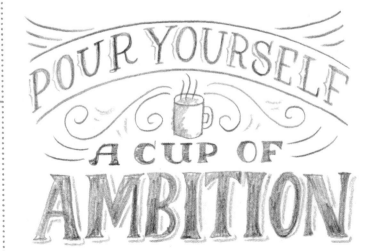

 TIP!

There are many ways to draw a serif: old style, modern, transition, slab, or triangular.

 3

Add some weight to the diagonals and curves to create a thick/thin look and add swashes or any other decorative elements that go with your concept. Even out the curves of any misshapen letter. The tighter the sketch, the better your drawing will turn out.

 4

Finalize your drawing with a pen, either with tracing paper or directly on top of your drawing. Wait for the sketch to dry and then erase the pencil lines.

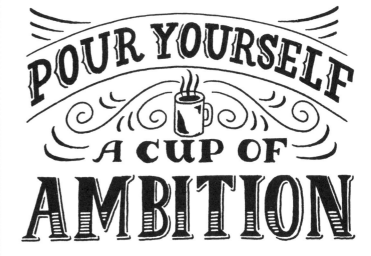

SANS SERIF

A sans serif style is one that does not have the small line, flourish, or embellishment trailing at the ends of the strokes. The term comes from the French word *sans* (without).

YAY! VARIETY PACK

ORIGINAL

SHOE

5¢

SHINE

N VENTURE OUT W S &

BOARDWALK

FRESH
FROM THE
FARM

SCAMS
& FLAMS

MANDATORY
FUN
· ENJOY ·

CABIN
FOR
RENT

TOOLS A fine-tip pen or marker

 Lightly sketch out your phrase in pencil, considering the sizing and how the word is going to fill the composition. Try lettering your phrase at an angle or in an arc for a more dynamic look.

 With a pencil, lightly go over the word again, this time considering the styling of the word. Be aware of the spacing. All the spaces between letters should *look* equal visually (although they may not be mathematically equal).

3 Add some weight to the diagonals and curves to create a thick/thin look and add swashes or any other decorative elements that go with your concept. Even out the curves of any misshapen letter. The tighter the sketch, the better your drawing will turn out.

4 Finalize your drawing with a pen, either with tracing paper or directly on top of your drawing. Wait for the sketch to dry and then erase the pencil lines.

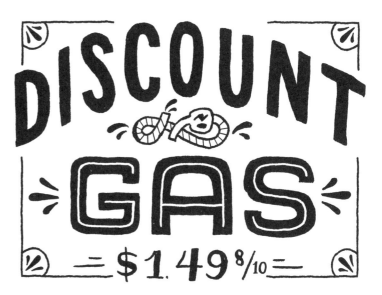

ORNATE

Ornate lettering is often used in headlines, drop caps, and greeting cards. It is very illustrative. It may include words made just out of swirls, letters with illustrative details, or letters with ornate serifs or swashes. You can use ornate lettering in a variety of fun projects like wedding invites or logos. This exercise will help you get comfortable adding ornate details to your letters.

STRENGTH

GELATO

ADVENTURES IN BOTANY

UGLY

610

 TOOLS ⟶ Pencil, eraser, fine-tip pen, marker

 1 Lightly sketch out your phrase in pencil, considering the sizing and how the word is going to fill the composition. Try lettering your phrase at an angle or in an arc for a more dynamic look. You may want to make a few thumbnails sketches to decide in which direction to go.

 2 After picking the winning sketch, lightly draw over the sketch, this time adding more details, such as a drop shadow, to make the fine points stand out and the phrase more legible.

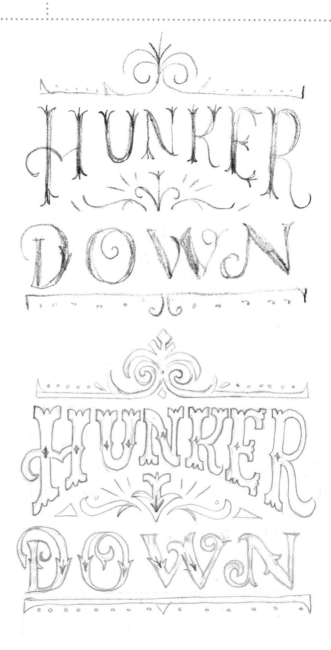

Use the content of what you're lettering but take small icons and insert them within the flourishes and letters. They should be subtle enough that they look like they are part of the decoration. For example, if you're writing something about fishing, use fish hooks at the ends of your flourishes to tie them back to the concept.

 3 Add details such as filigree and illustrations around the phrase to make the concept come through. Be sure to carry the same line weight throughout your word: you don't want your word to start off heavy and end light.

4 It's best to draw all the details your lettering will have separately and then assemble them in Illustrator. Trace your lettering in layers. For example, trace the base of the letters and then trace the decorative elements. This will save you time later when coloring your piece.

Scripts

Script lettering, which is similar to cursive and calligraphy, is often created with fluid strokes using a brush or pen and nib. This exercise is helpful for making more dynamic scripts than you see in your average handwriting. You will start to get requests for making beautiful script-y wedding invitations in no time!

9 OUT OF 10 unlicensed Physicians Agree

TOXIC TONIC

I Heart You

Cat Sound!

Exquisite

Varsity

Specials of the month

Easy

Make a Splash

Pain DON'T Hurt

 You may want to make a few thumbnails sketches to decide in which direction to go.

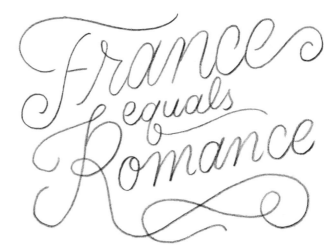

2 After picking the winning sketch, lightly sketch out your phrase in pencil, considering the sizing and how the word is going to fill the composition. Along with fun ligatures, look for opportunities to extend the descenders way below your baseline to create filigree.

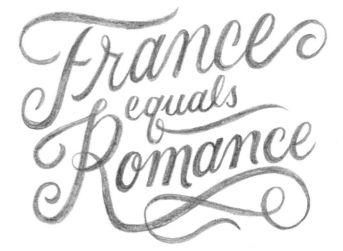

Avoid using too many swashes to maintain readability of the word. The first letter of the word is a good place to use an elaborate swash, as is a y, but too many swashes per word will become cluttered.

 3 Lightly go over the word again with a pencil, this time considering the weight of the letters. A thin script will have a more romantic sensibility than a thick one. For a more brush script look, add thickness to the downstroke; you can imagine where the heavier strokes would be if you were using a brush. Adjust the spacing as needed.

4 Finalize your drawing with a pen, either with tracing paper or directly on top of your drawing. Wait for sketch the to dry and then erase the pencil lines.

DIMENSIONAL

Dimensional lettering has exaggerated drop shadows which portrays the look of 3-dimensions. You can add drama to your lettering by using dimensional elements or drop shadows. For a heavy machinery look, you may want to add a beveled edge to your letters or a big drop shadow to a headline you want to stand out.

HOLE UP

The FUTURE is BRIGHT

STURDY

TOOLS — Fine-tip pen, marker

 Lightly sketch out your phrase in pencil, considering the sizing and how the word is going to fill the composition. Try lettering your phrase at an angle or in an arc for a more dynamic look. You may want to make a few thumbnails sketches to decide in which direction to go.

 Lightly sketch out the framework of your dimensional lettering. Then go back in with details as if you are carving away at the lettering.

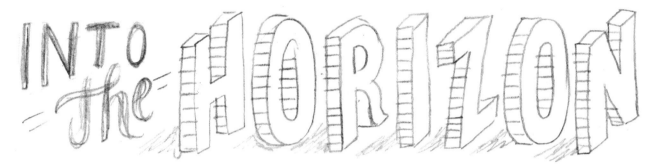

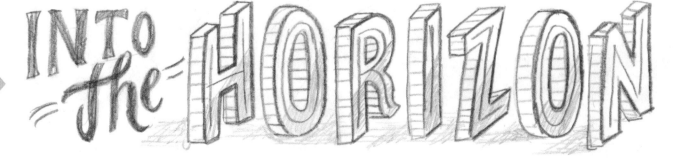

 Get creative with your use of dimension; think of representational-style dimension that could work for your lettering.

 Once you have the base of the drawing, sketch shadows or drop shadows with fine line work to create a more decorative look.

 Finalize your drawing with a pen, either with tracing paper or directly on top of your drawing. Wait for the sketch to dry and then erase the pencil lines.

 INTO the HORIZON

4 INTO the HORIZON

PLAYBILL

Playbill lettering is basically for your "old-timey" style and includes Western and circus-style lettering. It's a lot of fun to play with. For that authentic "old-timey" poster style, mix in different styles like serifs, sans serifs, and scripts. I often refer to old wood type for inspiration.

SEE THEM LIVE

No. 3120 ADMIT ONE

RESERVED

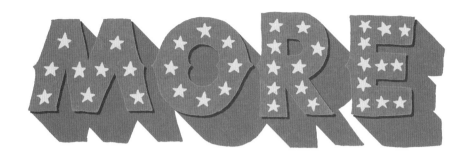

MORE

BEST
WORST

GOLD
DIGGERS

JACK
POT

TOPSY
TURVY

No. 6 — PLAYBILL

TOOLS Fine-tip pen, marker

In this exercise, it is good to start mixing lettering styles and to veer away from the overly used Rosewood font.

1 Lightly sketch out your phrase in pencil, considering the sizing and how the word is going to fill the composition. Use hierarchy to emphasize the important words. That is very popular in the playbill style. You may want to make a few thumbnails sketches to decide in which direction to go.

2 After picking the winning sketch, lightly draw over the sketch, this time adding more details to the ornate lettering. Play with different styles for the serifs: they are often exaggerated, so don't be timid.

TIP! It's important to maintain a snug fit but watch that your spacing is visually equal.

 3 Try adding a drop shadow to make the details stand out and allow the phrase to be more legible.

 4 Finalize your drawing with a pen, either with tracing paper or directly on top of your drawing. Wait for the sketch to dry and then erase the pencil lines.

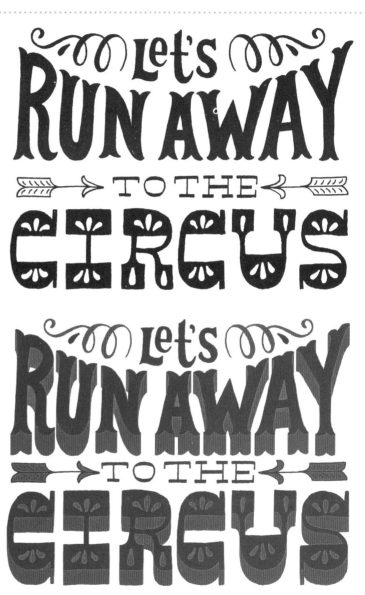

SIGN PAINTER

The sign painter style is great because you can see examples of it on the signage at your local grocery stores, tattoo parlors, and restaurants. Sign painting is an age-old tradition that is an artisan's craft; most sign painters learn the craft through apprenticeships. Needless to say, I have a huge career-crush on sign painters. It's a niche group with only a handful of great shops in each city. This style is similar to script, but the look we are trying to accomplish is to appear more like it's made with a brush.

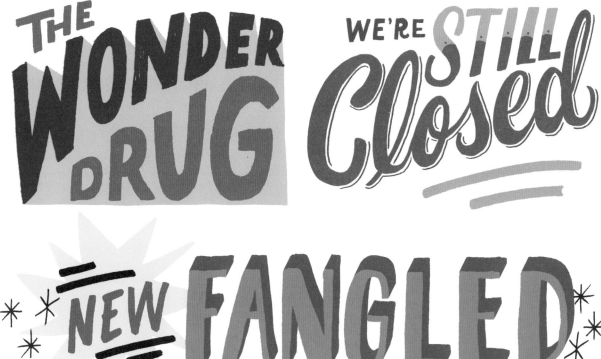

THE WONDER DRUG

WE'RE STILL Closed

NEW FANGLED

MARKET St.

BEST

SERVED

Totally

Chill

GOOD

CHEAP

FOOD

 Lightly sketch out your phrase in pencil. Be sure to mix script and sans serif styles. This is also a great opportunity to throw a number into your layout.

 With a pencil, go over the sketch, adding more details and making sure to add varying weights in the strokes to replicate the way it would look if it were painted with a brush.

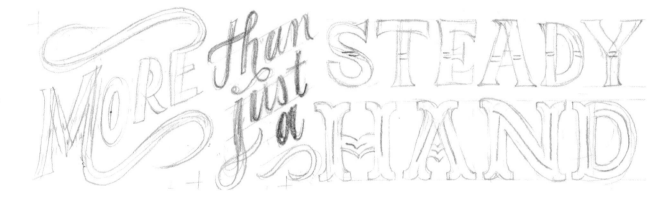

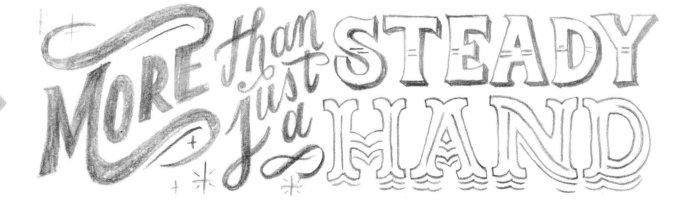

 TIP! Practice, practice, practice on paper but head out to a sign shop, grab some 1 Shot paint, and do some real-life sign painting on a piece of wood. It is very satisfying.

 3 Add some retro details and shapes behind the lettering to make your sign-painting style stand out. Play with line details in your letters as well; draw a line inside the letter to add that extra sign-painter-y look.

 4 Finalize your drawing with a pen, either with tracing paper or on top of your drawing. Wait for the sketch to dry and then erase the pencil lines.

3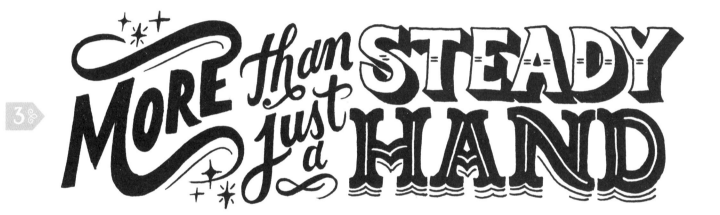

4

Black Letter

Black letter is a script that was used throughout Western Europe from the twelfth well into the seventeenth century. It features elaborate thick-to-thin strokes and serifs and is seen with dramatic swirls ascending from diagonal serifs. This style is used on a wide variety of applications, from formal diplomas to traditional newspaper nameplates, to badass metal tees, and even the Disneyland logo.

Mom

The End

MAY CAUSE
Nightmares
GOODNIGHT

THE
Spider's
CURSE

Nice

SWORD

FIGHT

YE OLDE

COLD

HEAVE-HO

Old English

TOOLS — Chisel-tip marker, fine-point pen, marker

1 Lightly sketch out your phrase in pencil. Try to replicate the curves and strokes of the black-letter style. Also, lightly sketch a border around your phrase and leave room for a little icon on top.

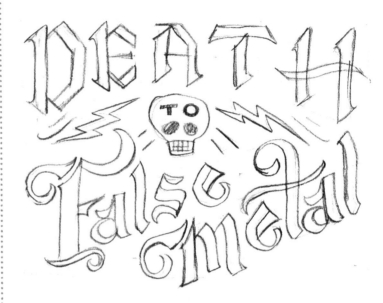

2 With a pencil, go over the lettering and add the thick strokes and the diagonal serifs. Add dramatic swirls to the serifs and end them with a ball terminal to add a more playful feel to the lettering. If you want to keep the badass effect, add a thick swash terminal.

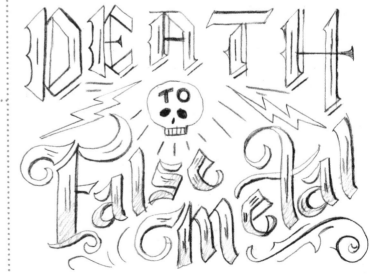

TIP! To create the look of a chisel-tip marker with pencils, tape two pencils together. That way you can create the framework of the letter and then trace over it with a fine-tip pen.

 3 Add a distinct style to your border that will go with your lettering style. Add some badass swirls around that icon. I drew a skull.

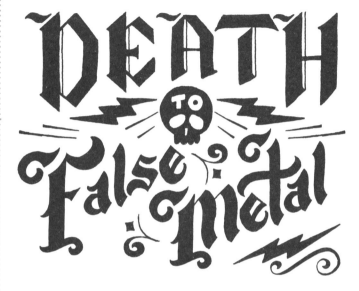

 4 Finalize your drawing with a pen, either with tracing paper or directly on top of your drawing. Wait for the sketch to dry and then erase the pencil lines.

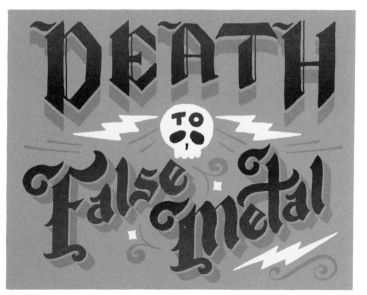

ILLUSTRATION AND LETTERING

Using illustration incorporated with lettering is a fun way to add interest to the composition and not rely as heavily on the tone of the lettering (though it is still important).

 Sketch out different compositions, experimenting with how your lettering interacts with the illustration. Pick your favorite and rough out the illustration and lettering.

 With a pencil, go over the lettering, adding the details to the illustration so the concept is clear. Be sure the illustration doesn't overpower the lettering and vice versa.

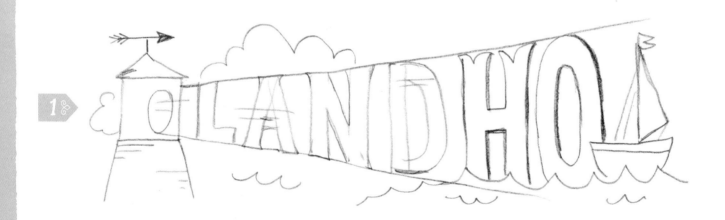

 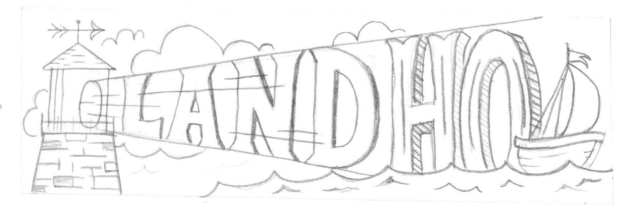

TIP! You don't have to have a realistic drawing style; simple line drawings look beautiful with hand lettering.

 Add other elements to the illustration to create a tight composition. For example, if you are drawing letters on a tomato, add vines and leaves behind it for a decorative look.

 Finalize your drawing with a pen, either with tracing paper or directly on top of your drawing. Wait for the sketch to dry and then erase the pencil lines.

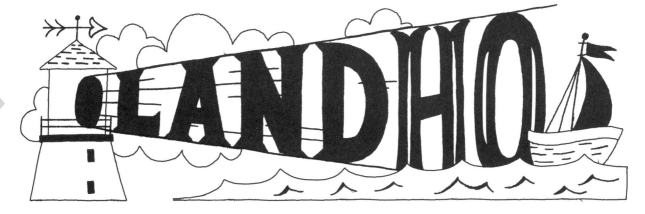

REPRESENTATIONAL

Representational lettering is a style that takes on the look of an object to create lettering. For example: ribbon, flowers, rope, twigs, pretzels.

Haircuts

FRESH

the Best Chats are over a cup of Tea!

LOST

Love

YOU DON'T MAKE FRIENDS WITH SALAD

Wotcha ZAP

 Pick the object you want to make out of letters and lightly sketch out your phrase in pencil. Be sure to keep it legible but be creative in how the lettering works.

 With a pencil, go over the lettering, adding the details of the illustrations so the concept is clear.

 The more organic the subject is, the easier it is to transform into lettering. For instance, it is difficult to turn buildings into letters (but not impossible). If you have an idea, go for it.

 Making representational lettering legible can be difficult, so while you are adding the details that make your lettering come to life, step back and make sure you can still read it.

Finalize your drawing with a pen, either with tracing paper or directly on top of your drawing. Wait for the sketch to dry and then erase the pencil lines.

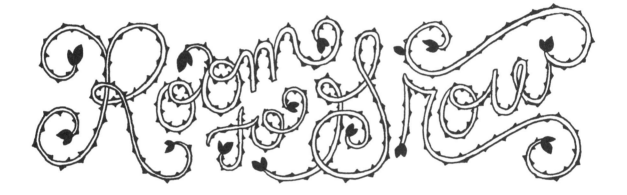

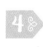

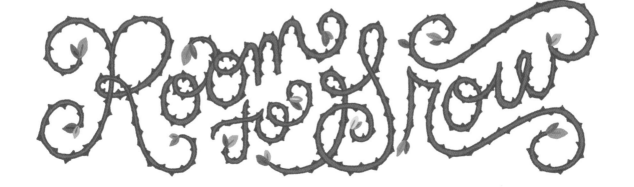

COMBINING STYLES

Combining styles is important in lettering. It's what will make your piece as distinctive and interesting as possible. Working with the awesome serifs you practiced earlier in the book and joining them with some sweet script lettering you have now mastered will result in a beautiful composition.

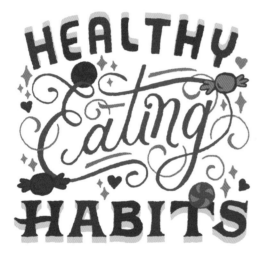

SIMILARLY DIFFERENT

THE
RED HEADED
· LEAGUE ·

BRASS
TACKS
HARD
FACTS

GRAND
Opening

PRIME
BEEF

 TOOLS Break out all the tools for this one.

 1

Lightly sketch out your phrase in pencil. Be sure to mix script and sans serif styles. Remember to try out some dimensional lettering; a simple drop-line shadow would work. Just trace a line around the letter, slightly to the right and the bottom of the letter.

 2

With a pencil, go over the sketch, adding more details, and be sure to add varying weights and serifs to some of the words.

TIP! Look for opportunities for ligatures. A ligature is the joining of two letters into one in a seamless fashion.

 3 Add a border to bring the composition together. Try borders shaped differently from the standard line.

 4 Finalize your drawing with a pen either with tracing paper or on top of your drawing. Wait for the sketch to dry and then erase pencil lines.

Date: _____ Style: _____

K&R STYLES

*R*s and *K*s are my favorite letters because there is a lot of room to play with the descenders. Starting with the basic letterform, exaggerate the descender by making it loop or swash. Draw a variety of *R*s and *K*s.

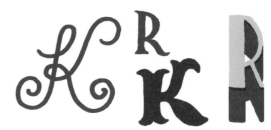

Date: _____ Style: _____

DROP SHADOWS

Drop shadows are a good way to add more personality as well as call out certain letters or words. Here are a few examples that you could try to include in your lettering. What else could your shadows look like?

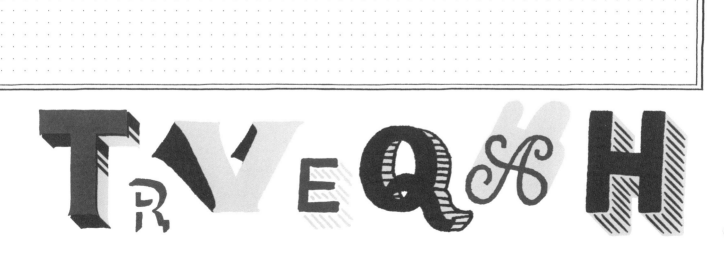

Date: _____ Style: _____

FILIGREE

Filigree is the swash-y decorative element you can add around words to make them stand out and add some pretty details. Start out with your phrase and add a border of filigree to bring the piece together.

Date: _____ Style: _____

DROP CAPS

Drop caps are used for the initial letter at the beginning of a paragraph. They are often decorative and very fun to make. Drop caps are commonly used in article openers and can be found in old, illustrated books. Say you are writing a short story or poem. You may not want to letter the entire thing, so a beautiful drop cap would be perfect to make it more graphic.

Date: _____ Style: _____

LIGATURES

Ligatures are the joining of two letters into one in a seamless fashion. The most common ligatures are used in situations where there is uncomfortable spacing, for example: *Th*, *fi*, *ff*, or *fl*. Some ligatures are more decorative. Look for opportunities to use ligatures in your lettering.

tt fi st North fig. ff it Th

AMPERSAND

An ampersand (&) is a logogram representing the conjunction word *and*. This symbol began as a ligature of the letters *et*, Latin for "and." The possibilities are nearly endless: You can really stylize an ampersand, and it will still read. Explore making your own!

Date: _____ Style: _____

 IN LINE

Add an in-line style to your lettering to create a simple decorative look. It can be simple or complex and doesn't always have to be a "line." The bolder the weight of your lettering, the more the in line will stand out.

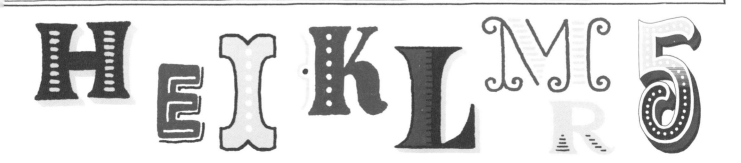

Date: _____ Style: _____

BANNERS

Banners are a beautiful way to display lettering and create hierarchy in your composition. They can be of a traditional or unconventional style.

Date: _____ Style: _____

SERIF *STYLES*

There is more than one way to draw a serif. You may be timid at first and initially draw small serifs but don't be afraid to branch out and draw big, chunky serifs. Try a new, adventurous serif style on this page.

SERIF

HALF SERIF

SLAB SERIF
no FILLETS

SLAB SERIF
with FILLETS

LONG POINTED

HEAVY ROUND
WITH FILLETS

TRIANGULAR

CUPPED

CALLIGRAPHIC

EXAGGERATED
FILLETS

DECORATIVE SERIES

HEADS of ASCENDERS

TERMINAL

A ball terminal is a circle-shaped device used to terminate a stroke, for example the arm on an *r* or the tail of a *y*. Other popular terminals are the lachrymal terminal, which is more of a teardrop, and the pen-formed terminal, which has the look of a chisel-tip pen. Use this page to practice varieties of ball terminals.

CROSSBAR

Another fun device to add to lettering is a crossbar, the horizontal bar made by connecting two strokes of a letterform, as in *H* and *A*. The ends usually meet at the stem, but you can experiment with ways of connecting the two strokes other than a straight line.

Date: _____ Style: _____

DRAW on a CURVE

Drawing letters on a curve can be tricky, but as long as
you map out the curve, you are in good shape. Draw your
desired curve on a template and cut it out. Use the edge
of the template to draw the curve and repeat. Now you
have an even curve.

DIG THOSE CURVES

cardboard stencil

A CURVY SANDWICH

cardboard stencil

CURVES

MULTIPLE CURVES

Date: _____ Style: _____

ITALIC LETTERS

Drawing italic letters is simpler if you draw slanted guidelines first. The slant should be about 10 degrees from vertical.

ABCDEFGHIJKLMN
OPQRSTUVWXYZ

Date: _____ Style: _____

APEX STYLES

The apex is where the strokes come together at the uppermost point of a character. These can be decorative or simple. Some examples are: rounded, pointed, hollow, flat, and extended. Practice drawing different varieties of apexes in As.

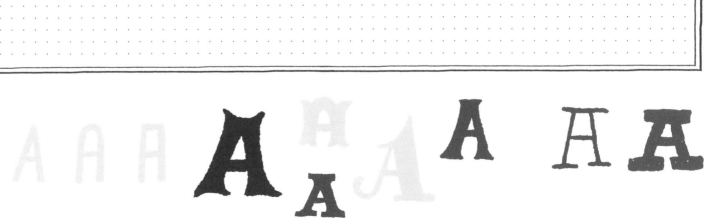

ABCDEFGHIJKLMN
OPQRSTUVWXYZ

Date: _____ Style: _____

TIP!

There are a few ways to draw the tail of a lowercase *g*:
open, closed, and not closed.

ONE-STORY
LOWERCASE
α

TWO-STORY
LOWERCASE
a

ONE-STORY
LOWERCASE
g

TWO-STORY
LOWERCASE
g

g

OPEN

g

CLOSED

g

NOT CLOSED

ABCDEFGHIJKLMNO

PQRSTUVWXYZ

Date: _____ Style: _____

SHADING

Add shading to letters for a simple, decorative look.

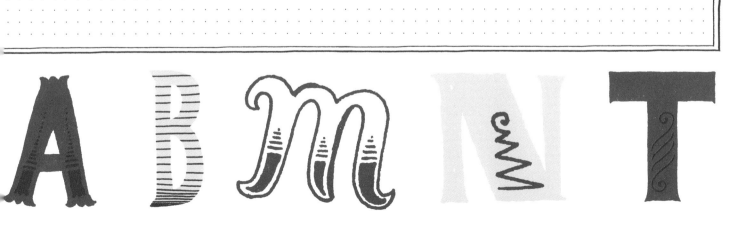

ABCDEFGHIJKLMNO
PQRSTUVWXYZ

Date: _____ Style: _____

LETTERING in SHAPES

Custom lettering to fit a shape is common practice because it is much harder to make a typeface fit to a shape than to draw it. Practice lettering in a simple shape and then choose a more complex shape or illustration to letter in.

ABCD EFGHIJK LMN
OPQRS TU VWXYZ

Date: _____ Style: _____

BORDERS

Borders are a great way to add an extra bit of interest to your layout. You can make decorative borders out of shapes, swirls, or lines. Try drawing simple shapes and designs and then create a border from those shapes.

ABCDEFGHIJKLMN
OPQRSTUVWXYZ

Date: _____ Style: _____

FAVORITE *quote, advice, idea*

Thinking of the content of the text to letter can be somewhat daunting. Advice you were once given, a quote from a movie or TV show, or lyrics are great for subject matter that is personal to you (no more "Keep Calm" and "When life gives you lemons . . ." please).

ABCDEFGHIJKLMN
OPQRSTUVWXYZ

Date: _____ Style: _____

HAND-DRAWN TEXTURE

Adding texture is a great way to finish a piece and to achieve a more hand-drawn look. There are many ways to add texture; you can experiment with scanning different surfaces to fill in your letters or play with custom Photoshop brushes, for example. An even easier way to incorporate texture is to add it right into your drawing. Using your fine-tip pen, fill in the letter but leave those scratchy gaps that give it hand-drawn character. Another option is to draw using a criss-cross pattern. Or, try using a brush: dip your brush in ink and dab it on scrap paper until it is a bit dry and then draw.

I MAKE More

ABCDEFGHIJKLMN
OPQRSTUVWXYZ

ABCDEFGHIJKLMN
OPQRSTUVWXYZ

ABCDEFGHI
JKLMNOPQR
STUVWXYZ